# Ugly Big Shoes
## Hilarious Vulgar Adult Coloring Book

## for Fun & Stress Relief

## By

## S.B. Nozaz

## Copyright © 2016 by S.B. Nozaz

All rights reserved worldwide. No part of this publication may be reproduced or distributed in any form or by any means, mechanical, electronic or stored in a retrieval or database system, without written permission from the copyright holder.

# DICKHEAD

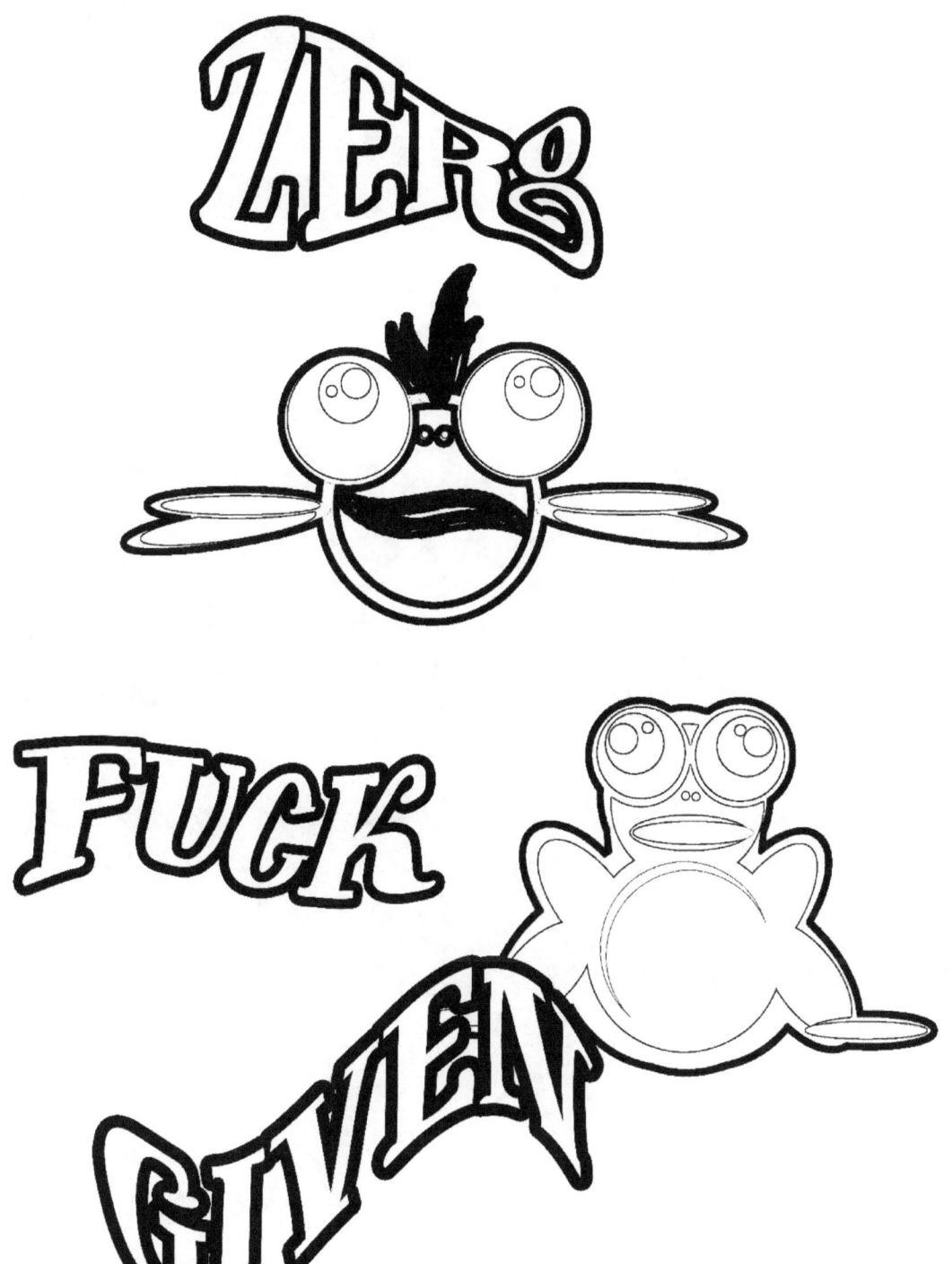

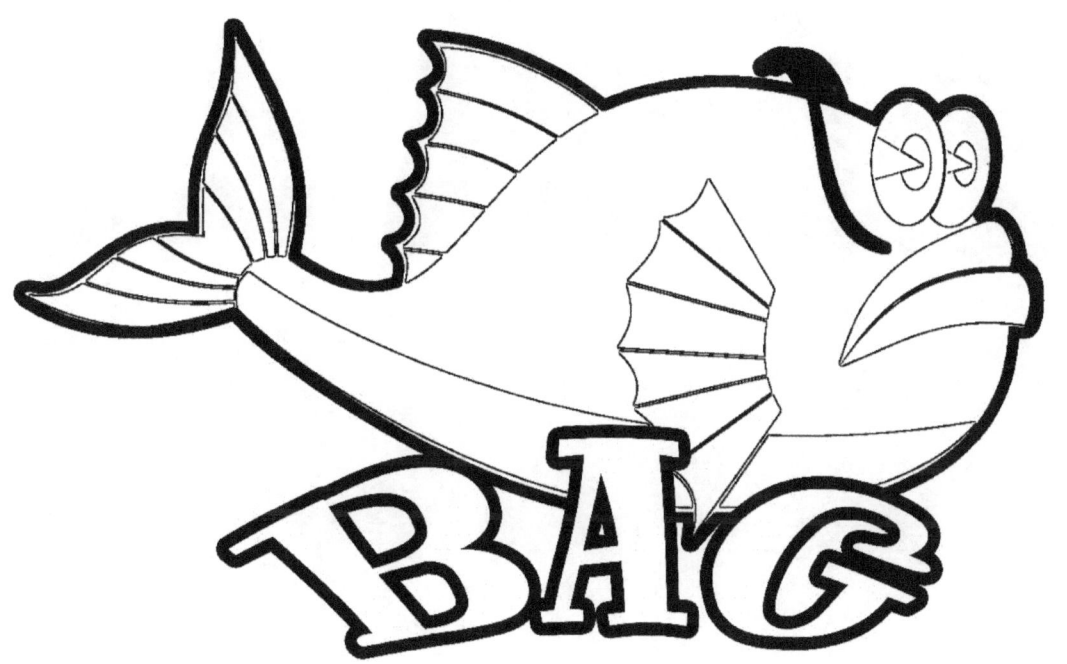

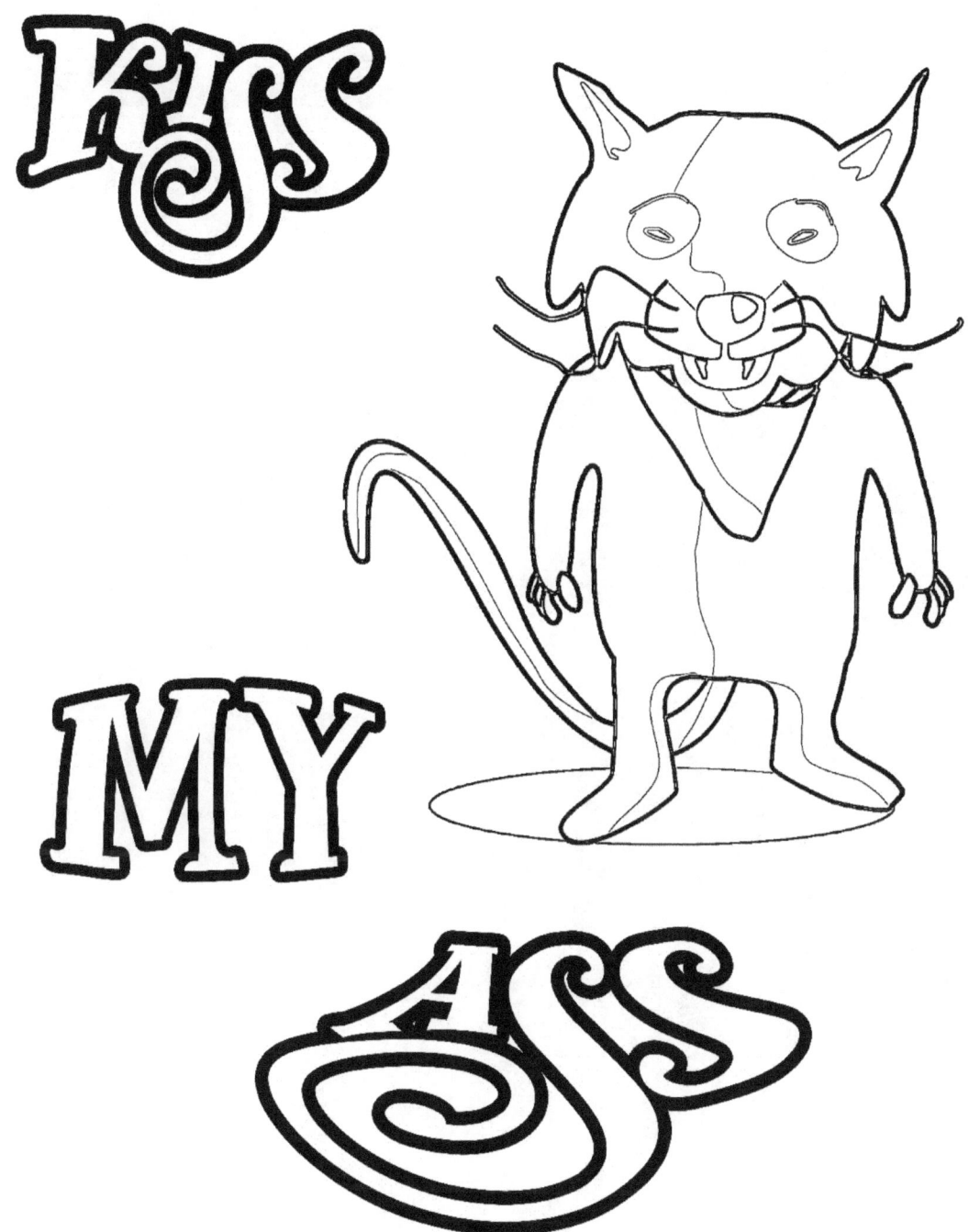

# CUNT FACE

# COCK AND BALLS

# BATSHIT

## CRAZY

# BITCH

# BULLSHIT

# LOW LIFE

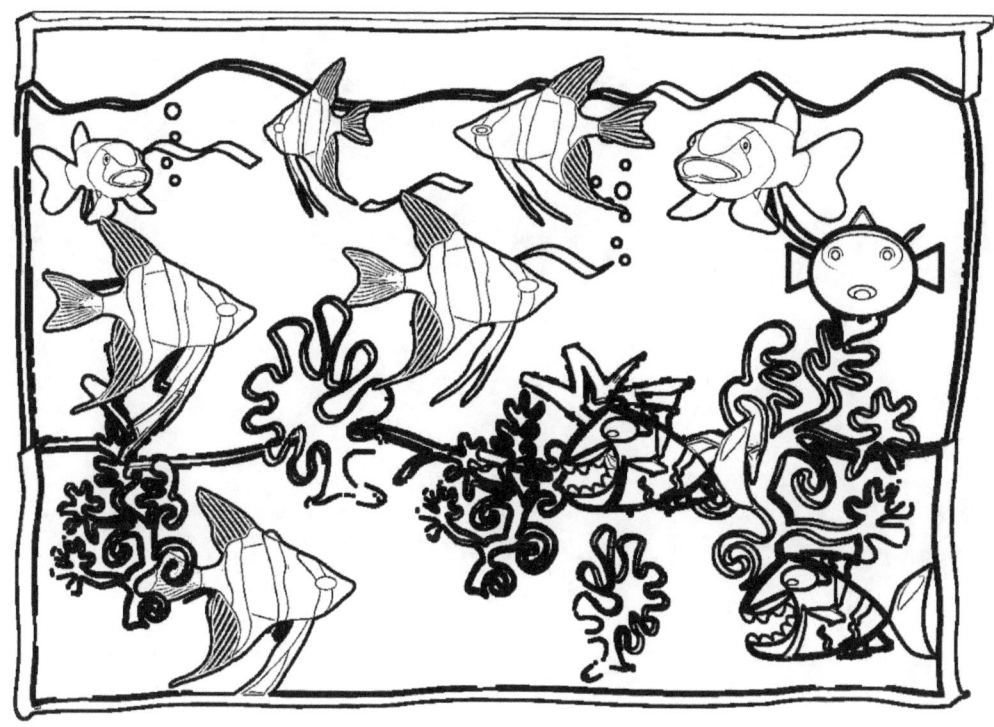

# HOLY

# SHIT

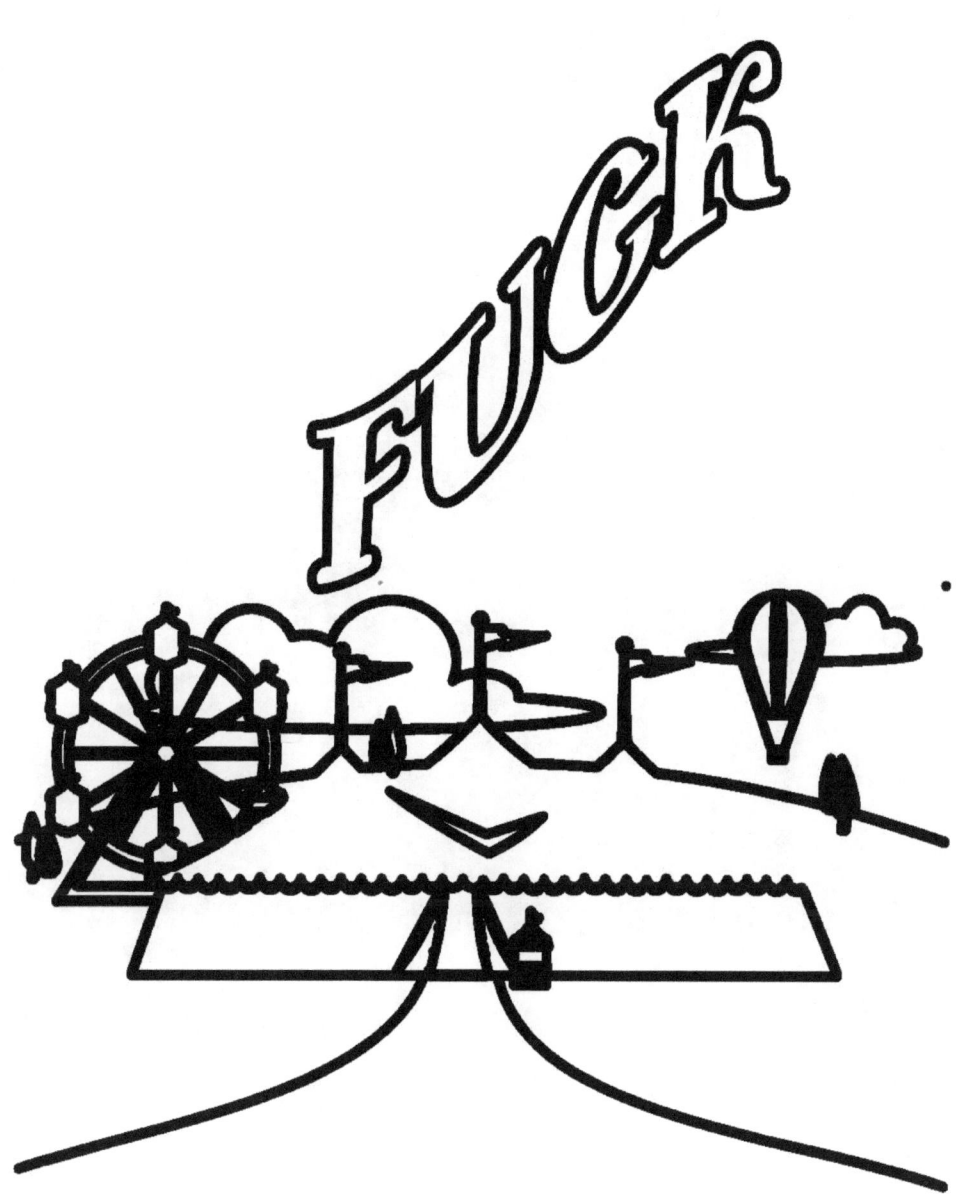

# MORON

# HOLY FUCK

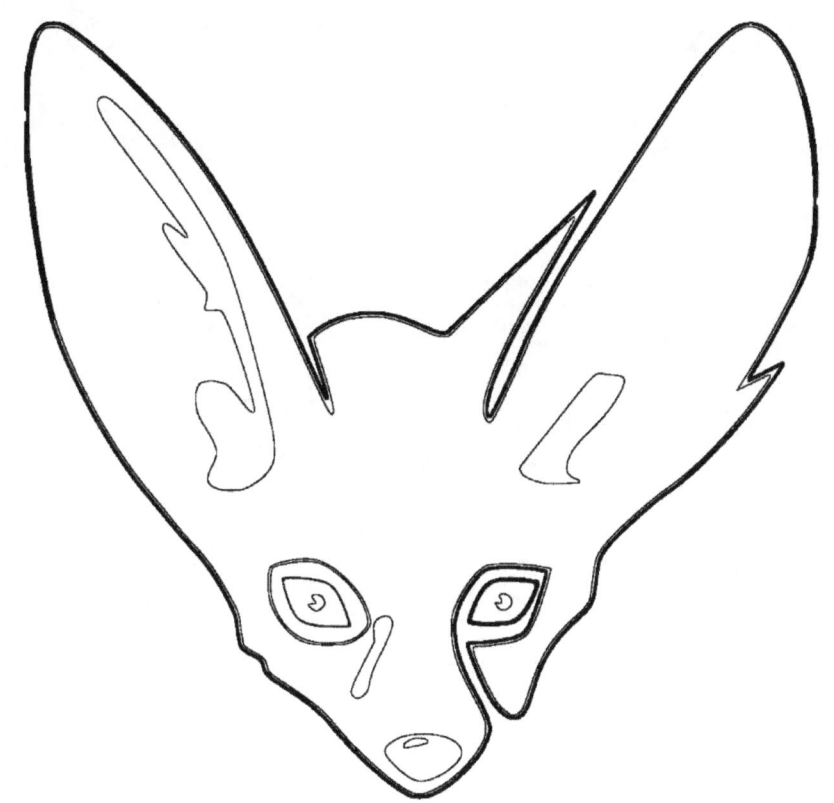

# DIPSHITIDIOT

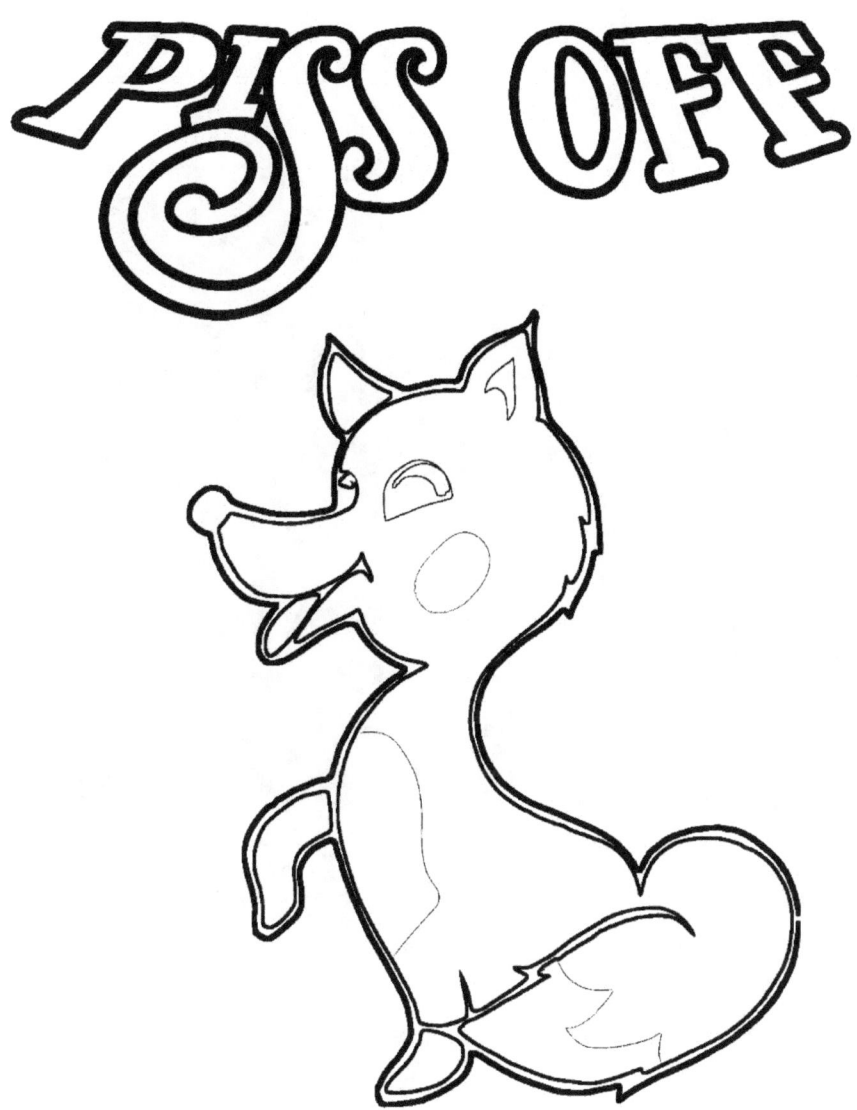

# Note

www.ingramcontent.com/pod-product-compliance
Lightning Source LLC
Chambersburg PA
CBHW080639190526
45169CB00009B/3429